THE *Quick* GUIDE TO PARENTING

Laura Quick

PAVILION

from what they said to the man at the bus stop, to where you found the remote control, when you're a parent, laughing at what gets hurled in your direction is beyond important.

By sharing our weaknesses and our 'what should I do now?'s' with eachother we can remove the perfect-parenting pressure we all place on ourselves.

My Grandmother told my aunt not to try to be perfect, but to just be ok. That way if your child removes its trousers and pants in the street and drops a poo on the pavement because you're talking to someone else, you won't feel you've failed.

YOU ARE NOT ALONE
I hope you enjoy the result of my labour...

I'd like to thank Mathilde & Lilou
for being my subjects. As well as
my many wonderful friends who
have shared their stories with me
and given me inspiration for so many
drawings. And Pinny, for suggesting I
do a book!

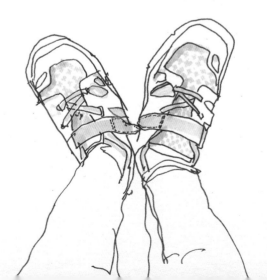

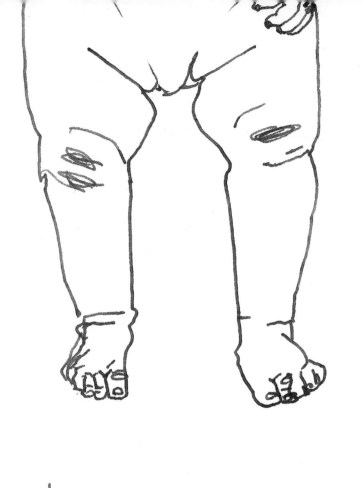

legs.

legs 7 years later.

Breast feeding

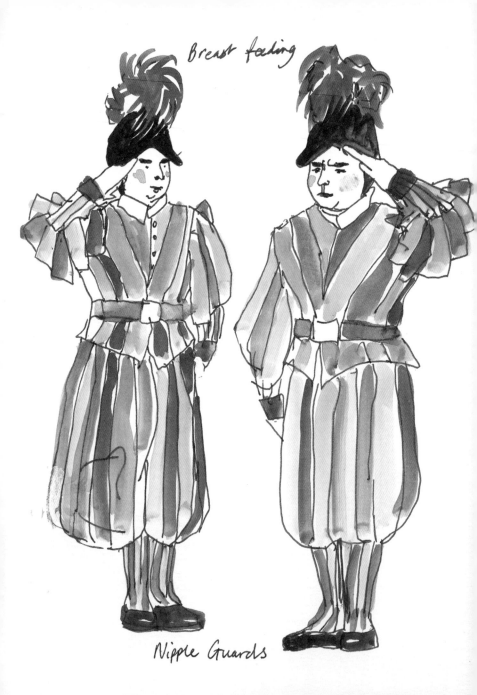

Nipple Guards

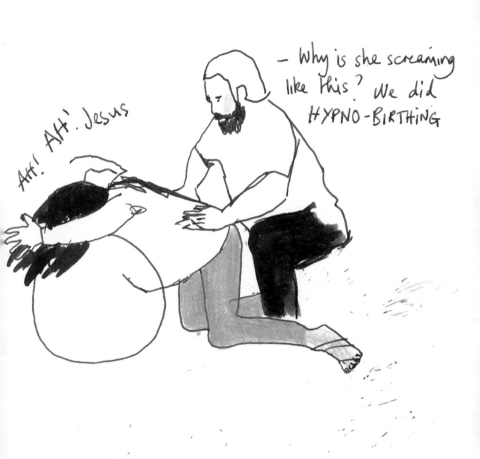

Anti Natal Yoga

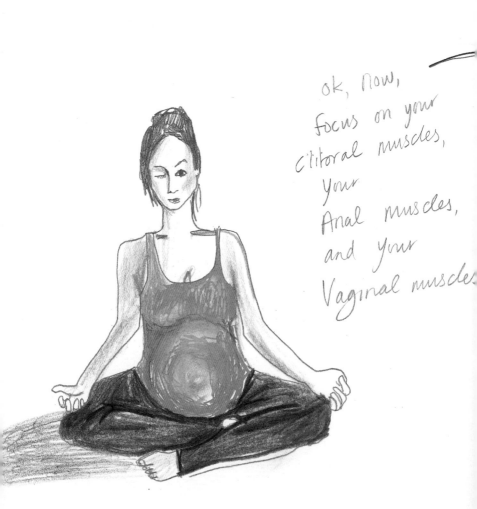

ok, now,
focus on your
clitoral muscles,
your
Anal muscles,
and your
Vaginal muscles

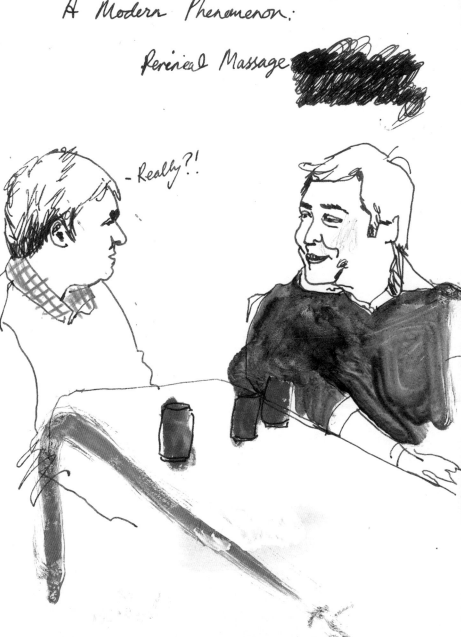

Top 10 Unrealistic Mother Promises

(NOTE) POINTS UNDERLINED IN RED ARE ESPECIALLY HARD

- To be a perfect mother.
- To be in control. RATIONAL
- To always listen. Even when they are talking shit.
- To be a cool Mum. With nail varnish.
- Not to shout in the street.
- To teach them to LOVE LOVE LOVE healthy food.
- Not to shout at them for being twats.
- To always have a shower before you smell.
- To lose weight simply by doing squats while picking up toys.
- Not to get annoyed with your partner.

white Lies

"Just popped to the pub for a quick one though, babe".

(1) (2) (3)

A situation arose regarding matching socks

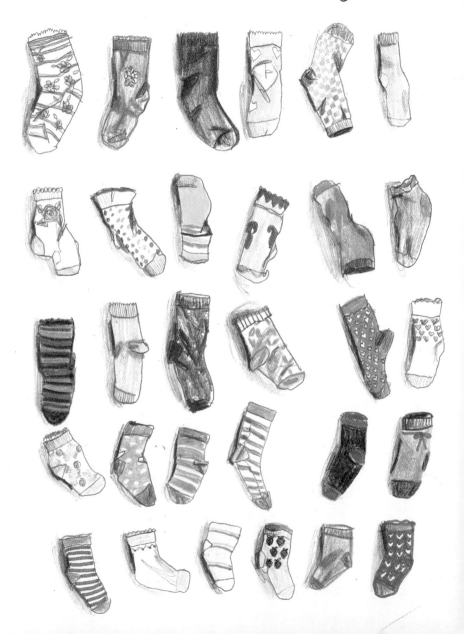

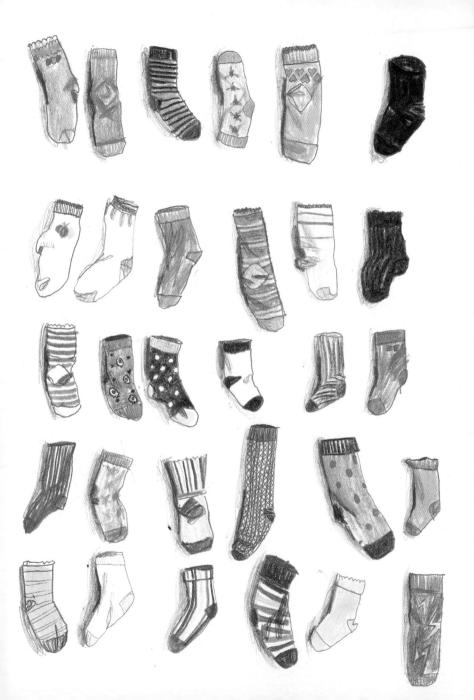

The inside of my brain today

The inside of my brain

Yesterday

the Baby needs her nappy changed.

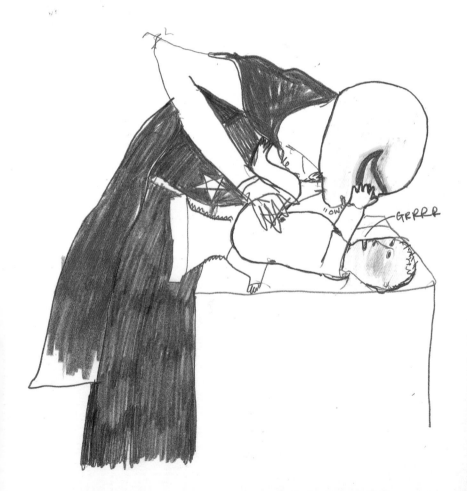

Muslins

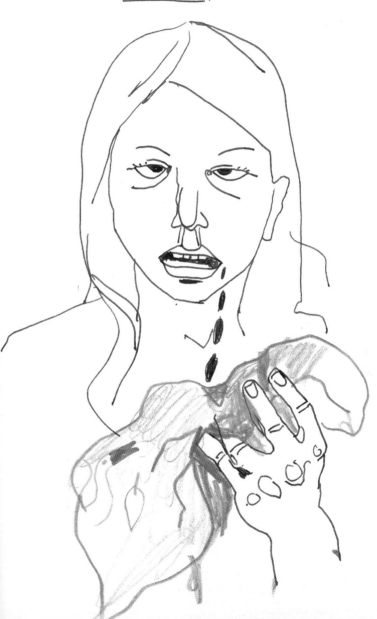

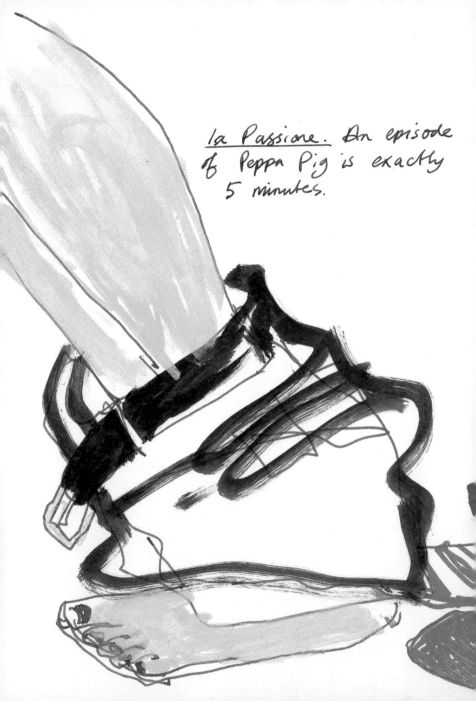

la Passione. An episode of Peppa Pig is exactly 5 minutes.

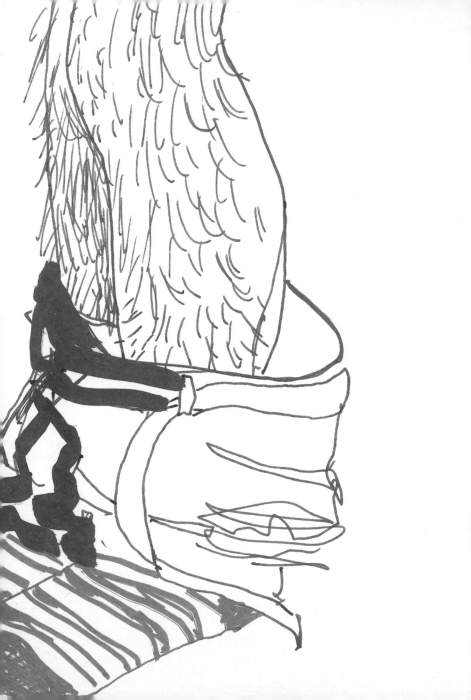

My sink after brushing my teeth
last night...

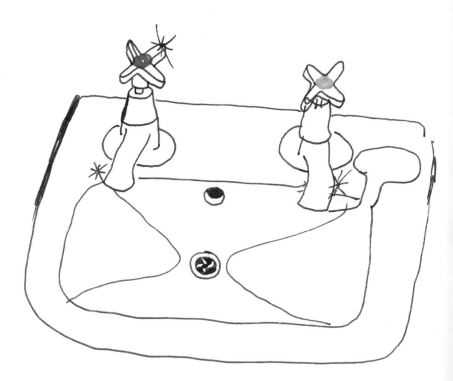

My sink after the family had
brushed their teeth this morning

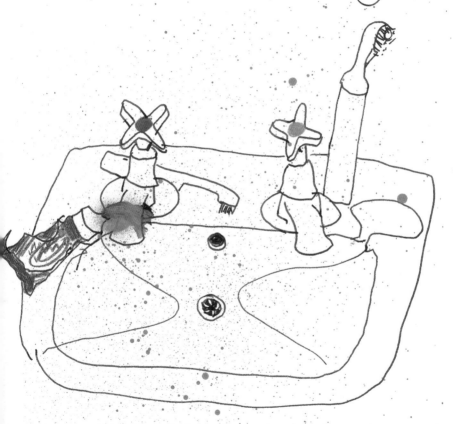

2 mums by the sand pit
childhood.

t the Museum of

Losing Weight

I TELL MYSELF EVERYDAY THAT I NEED TO
LOSE WEIGHT. SO I EAT FEWER KITKATS
AND, OCCASIONALLY, WHEN I REMEMBER,
I CLENCH MY BUTTOCKS WHEN I'M
WORKING AT MY DESK. BUT GENERALLY,
I FORGET.

I am not keen on the term:

M.I.L.F.

brighten your afternoon with a
little daytime TV.

he's
— Mine

I
hate
you! —

ME TIME

Mummy Hygiene

I smell slightly today. This is because <u>I have not had time to wash.</u>

I have attempted to mask this by applying an extra layer of deodorant.

Knowledge

— Mummy... how many hours are there in a day?

(ME) — 24.

— Oh my GOD!! you answered that straight AWAY! You know so much!

Skill

— Mummy, you are literally THE BEST egg spreader I know.

Accidental Phallus

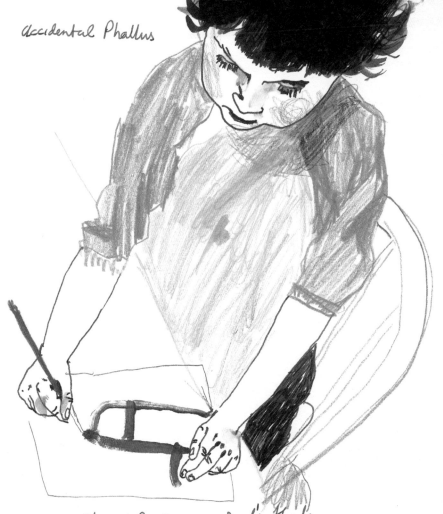

— Oh .. GOD .. What's that
you're painting ?!
— An aeroplane.
— Oh. Good. Good. That's great.

morning toddler head

Tidy Up Time

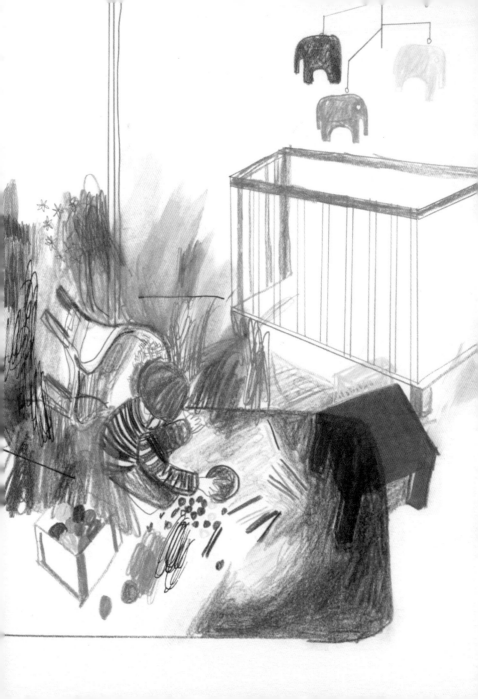

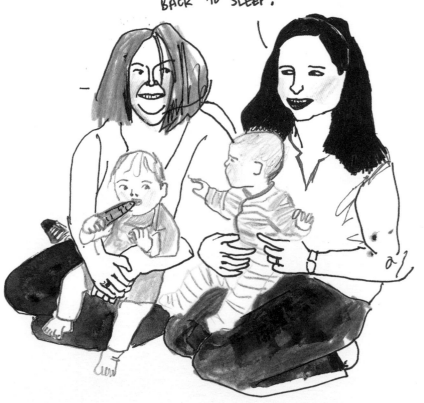

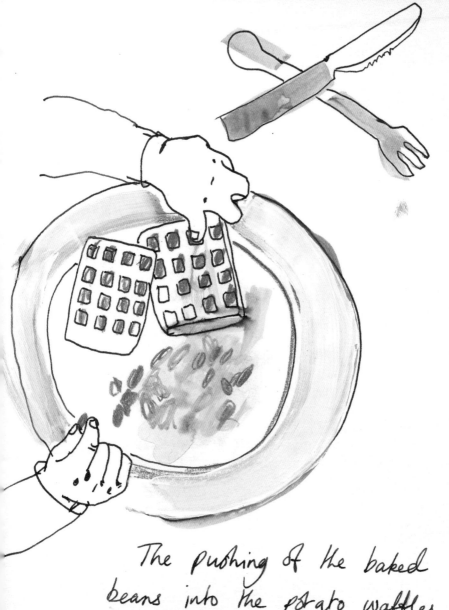

The pushing of the baked beans into the potato waffles was nearly finished.

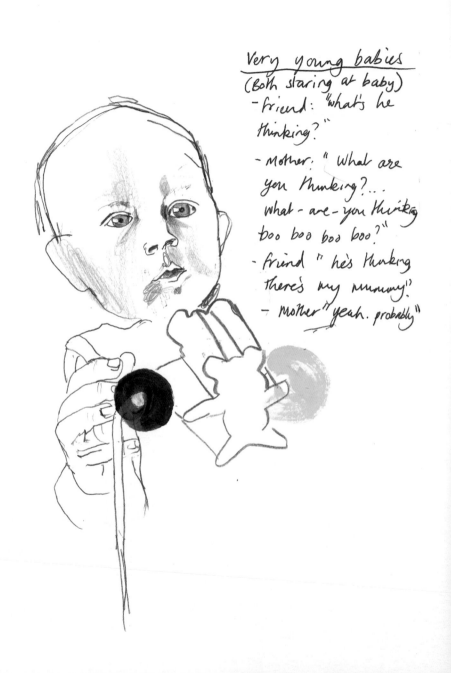

Very young babies
(Both staring at baby)
- Friend: "what's he thinking?"

- Mother: "What are you thinking?...
what - are - you thinking boo boo boo boo?"

- Friend "he's thinking there's my mummy!"

- Mother "yeah. probably"

Suntan Lotion

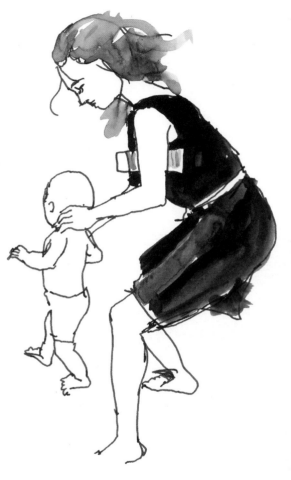

Smear and run,
Smear and run,
Smear and run

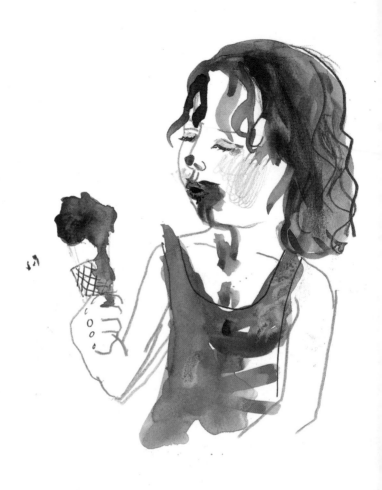

Too Much Ice Cream

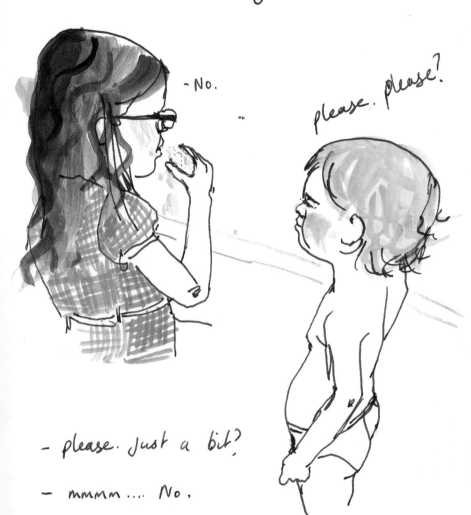

Stinky Bunny

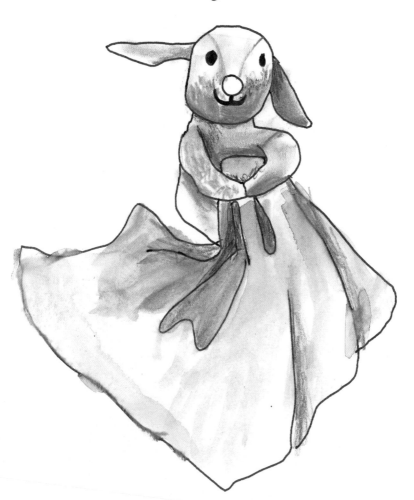

Owner: Noah

Flopsy

Owner: Mel

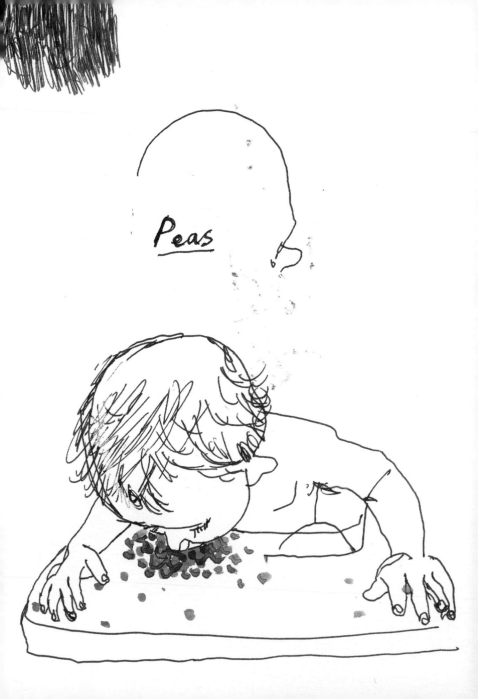

Peas

The olives were out, the wine was breathing, everything was perfect when I went to answer the door......

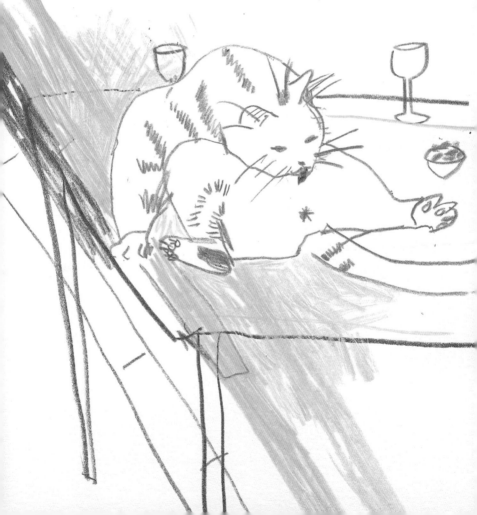

Survival techniques. #1

STANLEY AND HIS MOTHER

— <u>Mummy, CARRY ME.</u>

• I CAN'T, I'VE GOT A BAD BACK.... OH OK,
JUST FOR A BIT. OH MY LEG'S
GONE A BIT FUNNY, I MIGHT HAVE TO
PUT YOU DOWN.

— <u>DON'T PUT ME DOWN. USE YOUR OTHER
LEG, YOU'VE GOT 2 ..</u>

Arriving late at the
toddler group

~~Bum Crack~~ Parent $

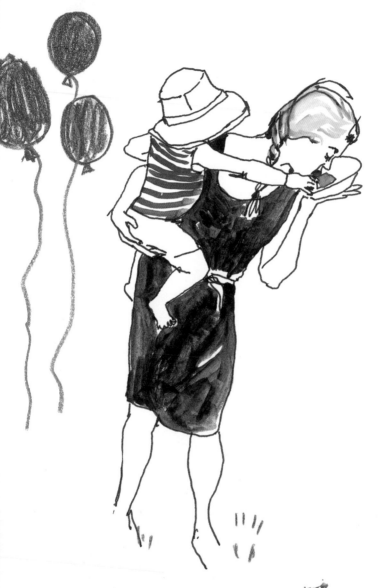

a little something to eat at the party.

Suspicious Eyes

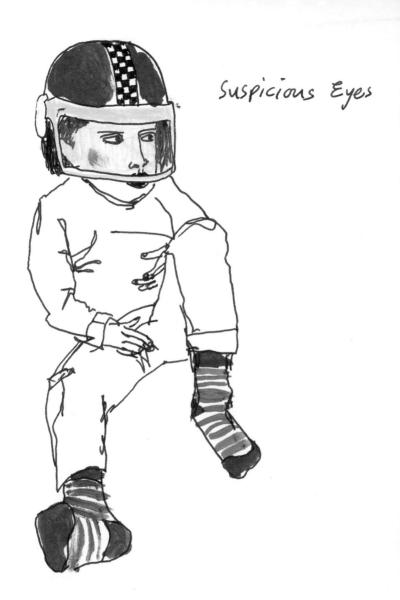

watching Mr Tumble

Another 3 year old test:

WHAT-CHA
GONNA DO ABOUT
IT?

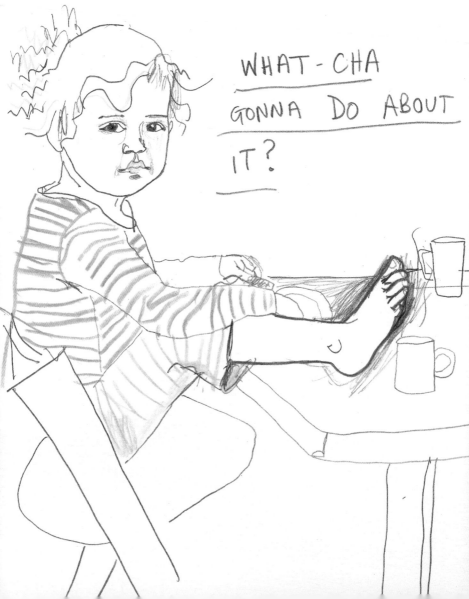

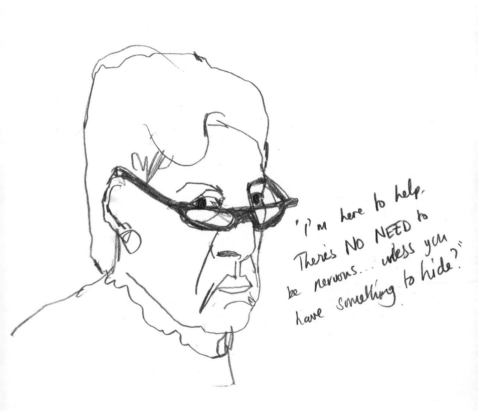

"I'm here to help.
There's NO NEED to
be nervous... unless you
have something to hide?"

— here you are, Mummy,
I picked it for you...

your small breath and your
feet in my hand.
The top of your head fits under my
chin, the fuzz of sparse hair.
And tiny shoulders.

Little soft squishy legs.

My arms go around you.
encase you. I can feel your
little stomach & chest rise and fall
to a faster rhythm than my own.

Your small fingers absent-mindedly
running along the form of my
hand.

Your breath, although it's morning
is lovely & warm.
Your shoulders, rising and falling
in time to the song playing on
Peppa Pig.

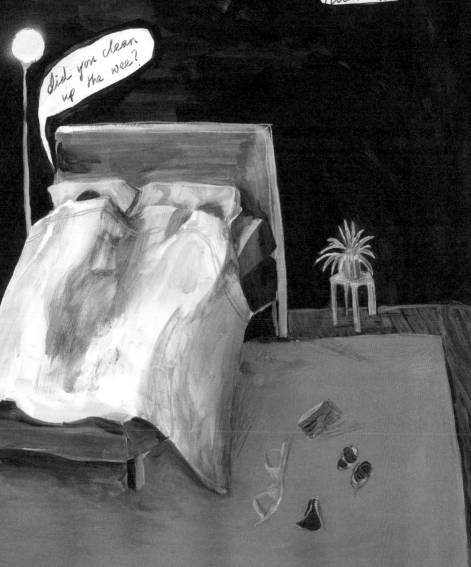

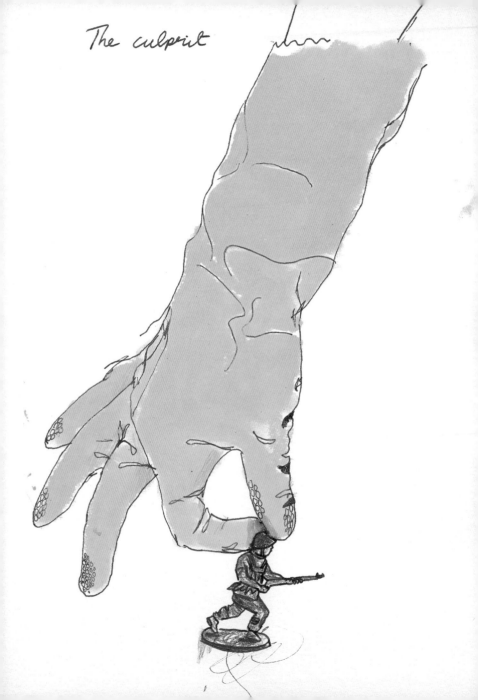

The culprit

Rewarding Good Behaviour

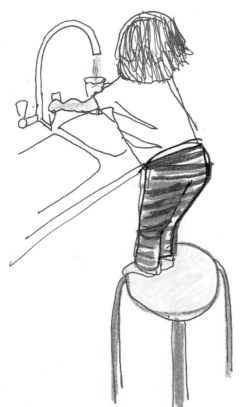

'That's great. You got the water yourself'.

—'Can I have a sweet then?'

- Come on or we'll be late.

- I..I..I..I.. I can't... I can't step on
the cracks or the bears will come up...
or sharks.

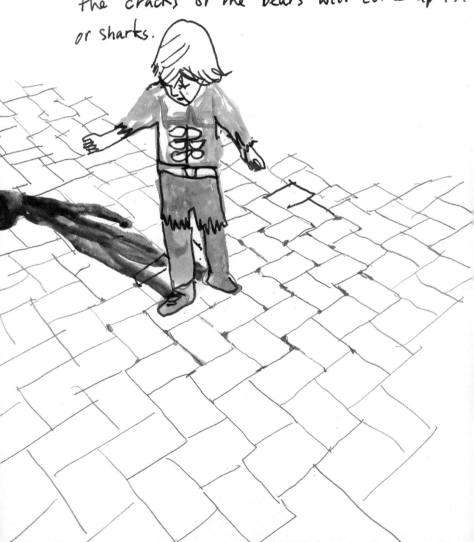

did you peel off the Wallpaper?

Caught in the act.

Guilt

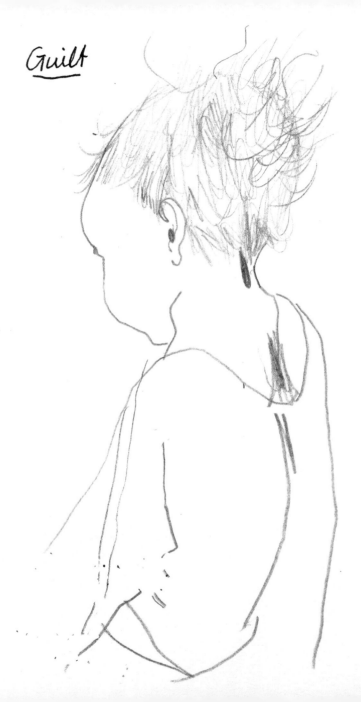

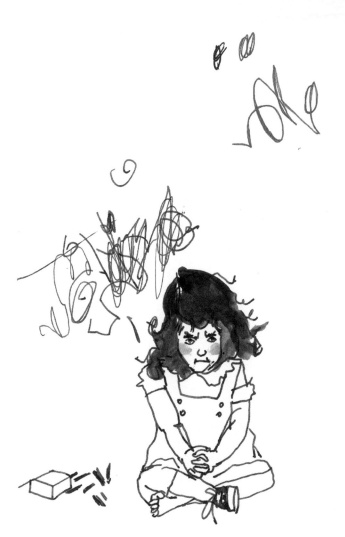

Guilt 2

Backwash

On the beach

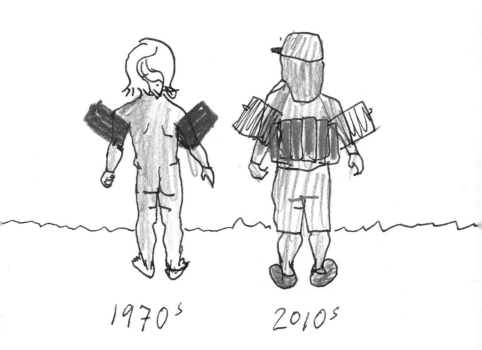

1970ˢ 2010ˢ

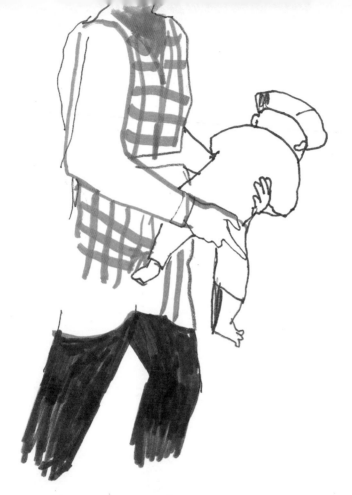

How to hold a baby

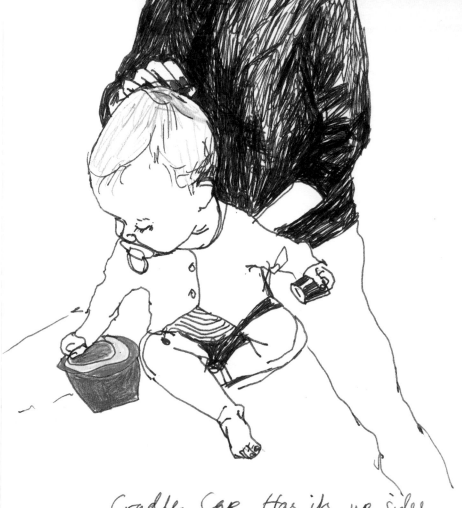

Cradle Cap. Has its up sides.

1. Picking Cradle Cap Is Relaxing
2. staring at it and working out which bit will be good to pick later, is exciting

Wasted Sentences
- don't do that, darling. It's rude.

You WiLL eat your
line - caught cod because
it cost £7 and took me
an hour to make it.

Panda

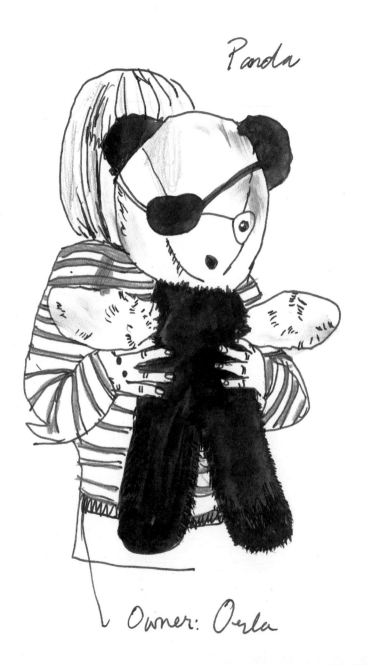

Owner: Orla

Louisa

owner: Pippa

— Did you hide the eggs behind the curtains?

-yes?

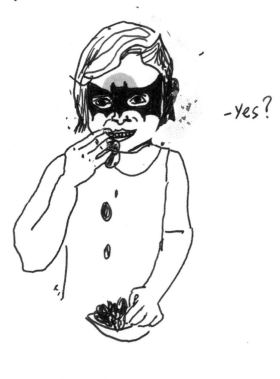

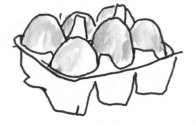

I found a box of eggs on the carpet in the corner behind the curtains. They were 2 months past their use-by date and like small grenades ready to go off at any moment. I knew immediately who the culprit was, but didn't expect such a total lack of remorse. She barely blinked at the question and continued to stuff her fistful of crisps into her fat little chops.

"Put the chapstick down..."

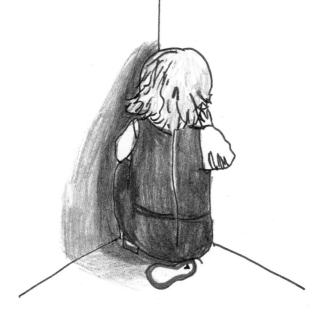

(She had already eaten half the strawberry chapstick by the time I found her.)

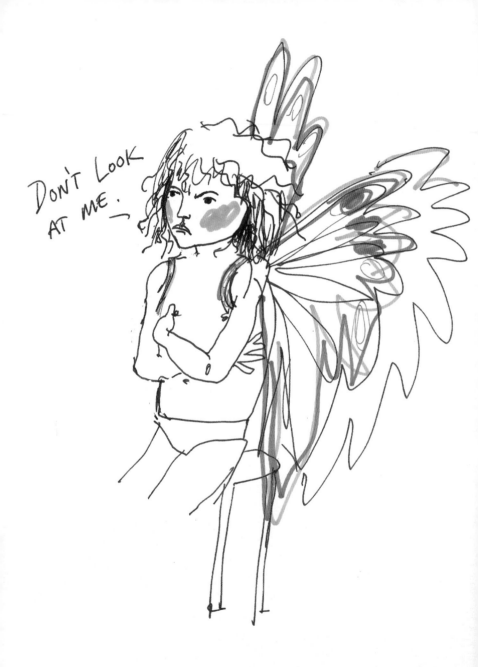

"please don't — squeeze so hard darling"

— "I'm just cuddling her. She likes it."

Extremely tight cuddles for baby sister...

Mummy, he looks like he needs to go on time out.

→ I'm hungry
– I'm hungry
– Don't copy me
– Don't copy me
– Stop it
– Stop it
– I'm the most annoying child in the world
– I'm the most annoying child in the world
– Ha Ha! You just said you're the most annoying child in the world!
– I hate you.
– I hate you too.

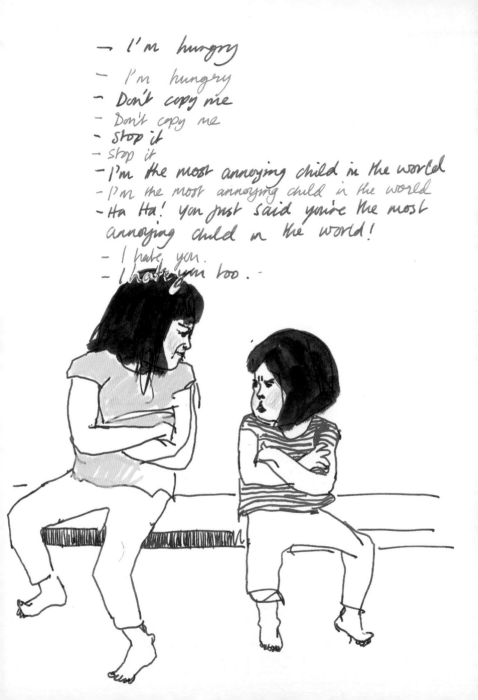

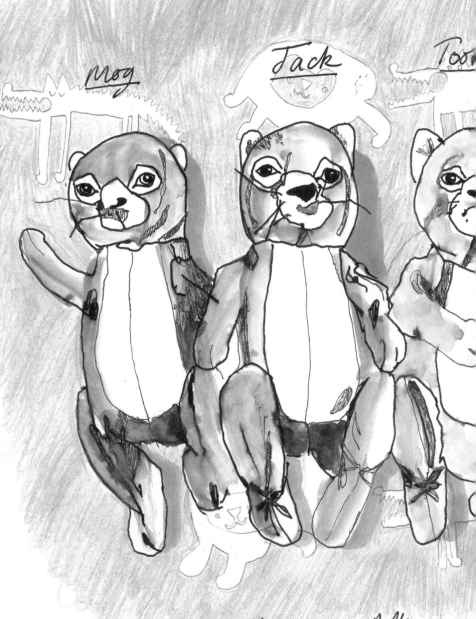

Mog

Jack

Too

"The Twins". Owner: Alfie

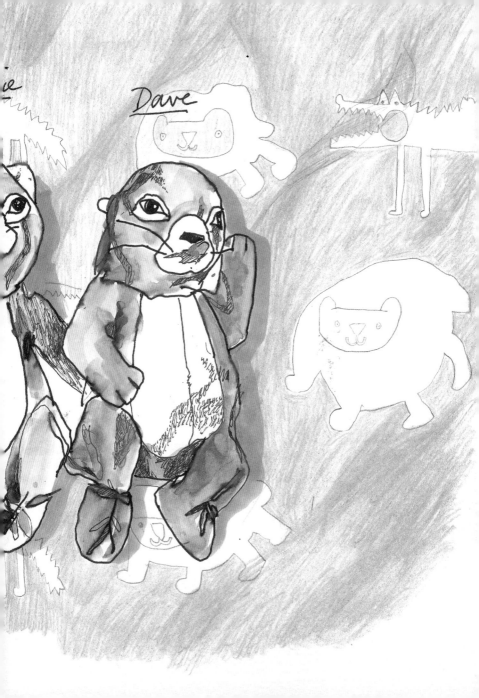

Dave

it's everywhere.

Ice Cream time

Throwing Stones

Nasal exploration

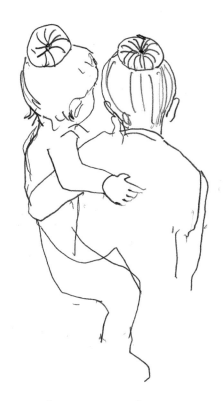

Matching Donuts.

a detailed account between
06:00 and 07:03 Saturday

05:57. BEDROOM. ENTER THREE-YEAR-OLD.
I am asked (told) to remove nappy
WITHOUT removing pyjamas. AT ALL.
(a normal procedure. I'm good at it.)

06:02. told to keep my eyes open. I am
not to go back to sleep - "keep your eyes
open... don't go back to sleep"... in fact,
"GET up WAKE UP!!". demands cereal,
she's starving.

06:03. I'm told my breath is stinky. My
hair looks messy. Told to brush my hair.
06:04: We go downstairs and discuss cereal
choice as we go.

06:05 crush the bowl of Special K (this weeks'
favourite) into the smallest possible particles
before adding milk.
06:07 find the small black handled spoon
by going through the drawers and the
dishwasher. (silver-handled or large-format
spoons not acceptable)

06:10 I turn away and on turning back see cat is sharing special K. push cat off table. Replace licked cereal, ignoring demands to wash it with soapy water.

06:14: Sit next to her. Not that side. The udder side. I do not change sides as I am drinking my tea (and I'm tired of being told what to do.)

06:15 Asked to take the illustration of the woman off the packed lunch tin on the table because "she's horrible & I HATE HER".

06:18 I listen to the "sit next to me" song for 5 WHOLE painful minutes. It is done in the style of a football stadium chant. She wins. I sit next to her. ill do whatever it takes.

06:23. she explains, out of the blue, that she HATES stinging nettles. We need to get rid of the ones at camping. We need to do it today. (we went camping 6 months ago).

06:26: points to the young apricot tree in garden & explains: "Those coconuts were not... erm.... I, I, I, I, I.... I, I, I, I, didn't make them fall off. It was the burglar... he shook it really hard".

06:30: A quick rendition of Wheels on the Bus including actions. Small spillage of cereal due to over-enthusiastic actions of bus wheels.

06:35: Impromptu declaration of love for me, including a large and vice-like cuddle around throat and heavy snot-filled breathing directly into my ear.

06:45: Takes a cherry from fruit bowl. tries to violently stick thumb into cherry. This apparently hurts the thumb. Demands a plaster. I explain that it's cherry juice NOT blood. This reminds her that her mate, Thomas, cracked his head open at nursery. She tells me in detail for the fifth time (also that he is alive). Reaches for another cherry singing a new made-up song called "Cool Cherry Cherry, cherry, blood cherry".

06:50: Wants to watch telly. My attempts to persuade her to play with dolls house unsuccessful.
06:55: I give in and switch on telly so I can lie down...
06:56: Choosing what to watch. She hates:

Baby Jake
Zingzillas
Mr Tumble
Sponge Bob
Mr Bloom (phwooor)
We settle on Ben and Holly's Little Kingdom.

06:57: Ben and Holly finishes after only 2 minutes.
Anger and Outrage. She HATES the adverts. They
are stopping her watching telly. ON PURPOSE. I explain
that she has to wait and then it will be Peppa Pig.
It works.

07:00 Silence as Peppa Pig starts. I lie down on
sofa. I close my eyes.

07:03 Big sister comes downstairs & changes channel
without prior consent. Shit HITS FAN.

 — TO BE CONTINUED —

- "Mummy what's that?"
- " "it's ginger".
- "Why?"

the house is quiet.
the little chair sits empty.
back to school.
Thank fuck for that.

September 3rd

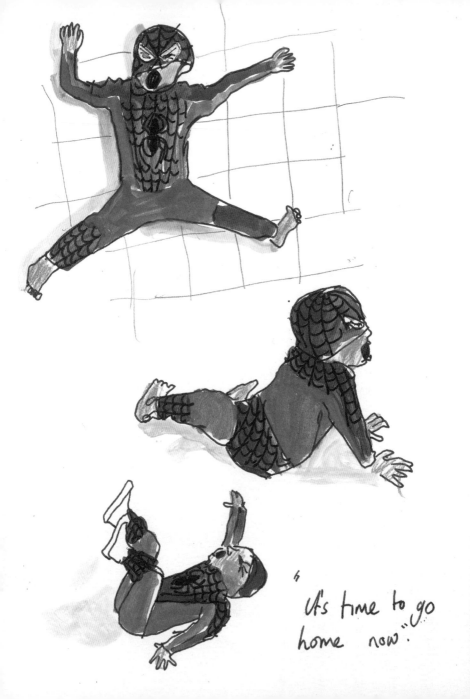

"It's time to go home now".

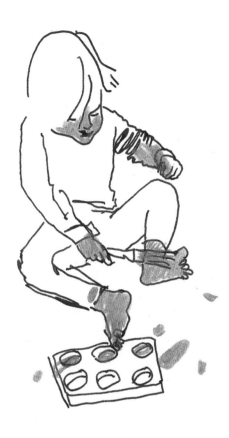

left unattended

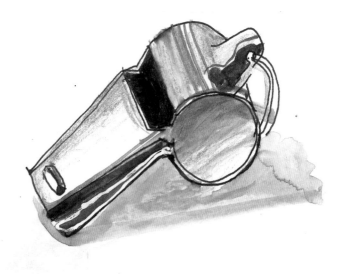

Advice: Do not buy your 5-year-old a whistle.

Enthusiasm on
a rocking horse.

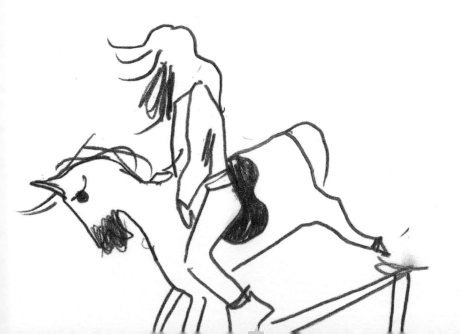

hating stuff.

whats for dinner? —

- potatoes

I HATE potatoes

On turning over the iPad...

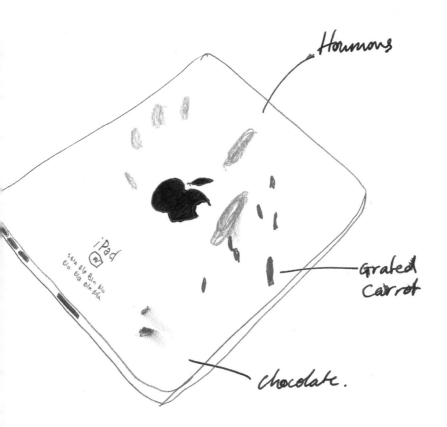

Houmous

Grated
Carrot

chocolate.

Anything is your tissue.
Everything is your tissue.

Mum **Mum**.
Mummy. Mummy!
Mum. 1, 1, 1... I need a plaster!

"you don't need that many hair clips... Here let me take some out..."

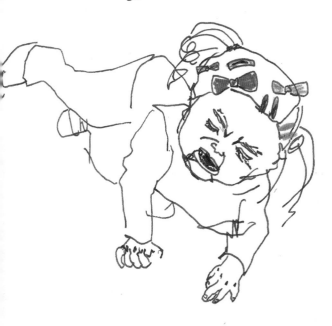

Big Ted.

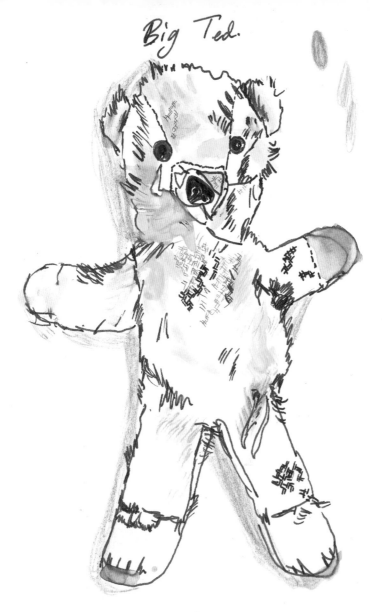

owner: Lila

Roger

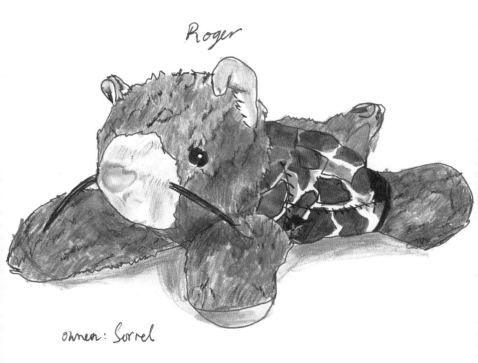

owner: Sorrel

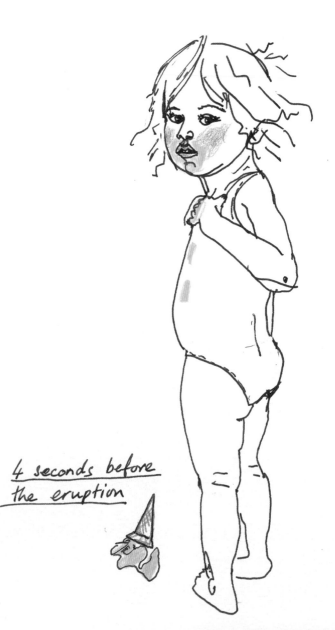

4 seconds before
the eruption

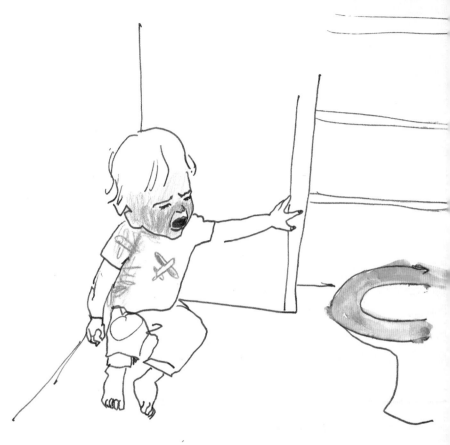

I flushed the toilet
before you saw the poo.

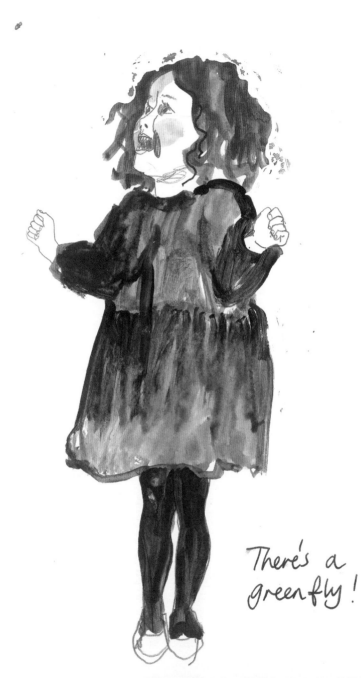

There's a
greenfly!

Concealing my irritation

The second I strap you into the car seat, you whip off your shoes & socks as fast as you can & drop them under the seat.

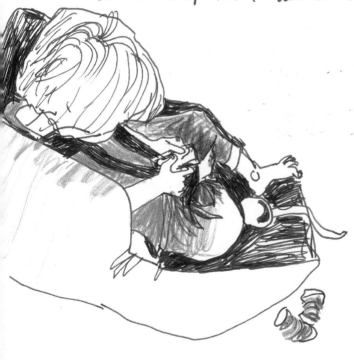

OLD LADY "Oh haven't you got lovely

- "NO!"

"ıg brown eyes."

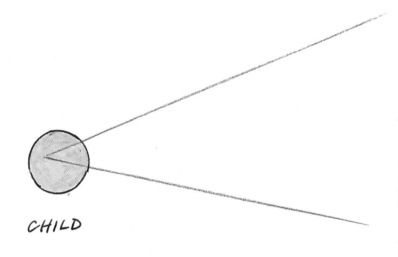

CHILD

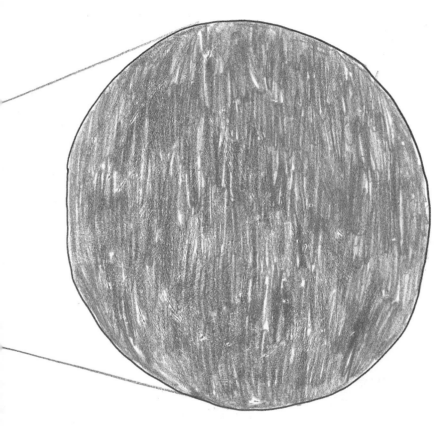

MESS

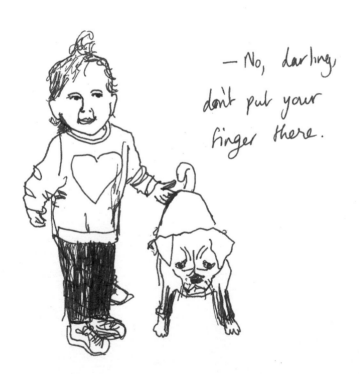

— No, darling,
don't put your
finger there.

half a second before the
balloon burst.

Weird Ballet face

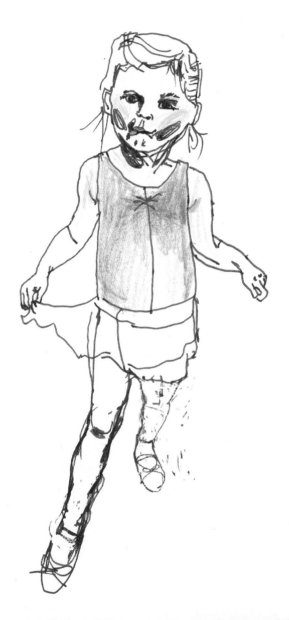

conversation with my daughter
(5 years old)

- Mum? What am I allergic to?

Me - Nothing.

- That's not fair. I want to be allergic to something.

Me - why?

- EVERYONE has one, except for me, Joni, Betsy, Anahita, oh, no, she's deaf. I used to be deaf.

Me - A bit, but you had an operation and you're fine now.

- I know. We need to think of something.

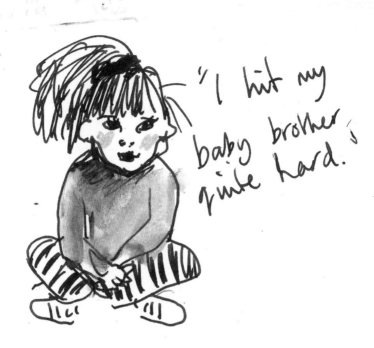

"I hit my baby brother quite hard."

me:- "Oh? What did your mummy say?"

- "She doesn't know."

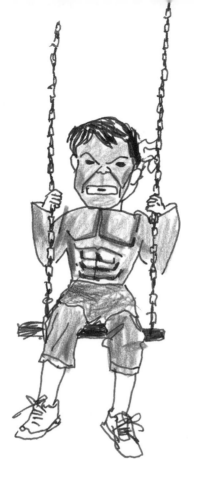

well push me
then....

4 hours dressed as the
Incredible Hulk.

Boy in shark suit for Pirate show

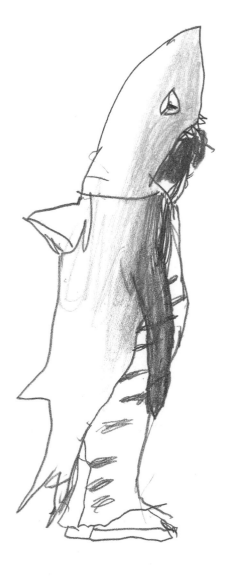

Pissed off at the Pirate Party

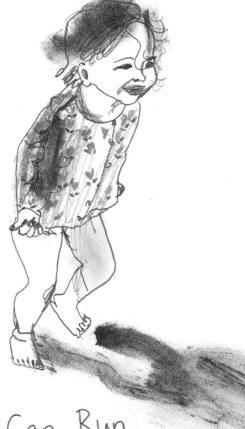

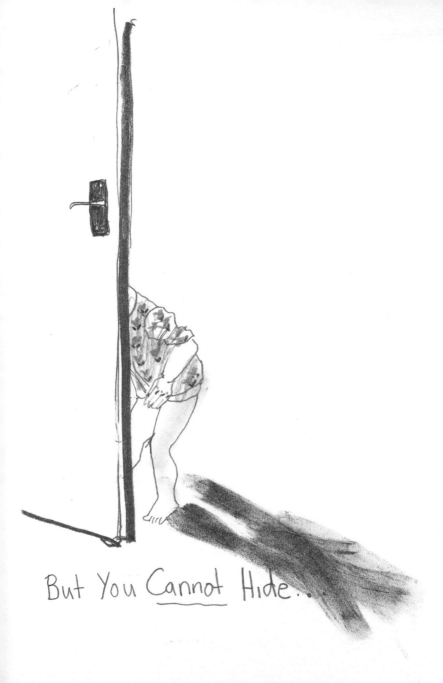

But You Cannot Hide...

watching TV in pyjamas +

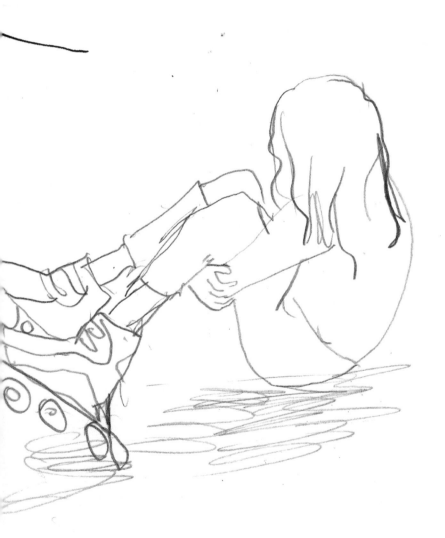

rollerblades. 06·07am

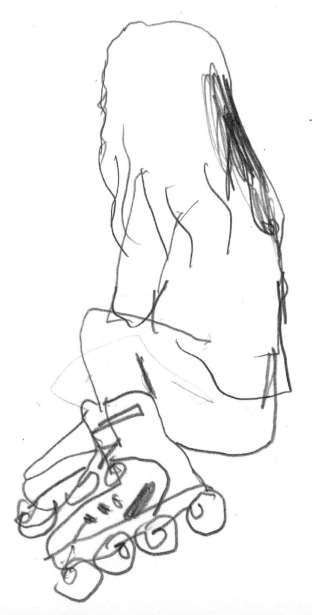

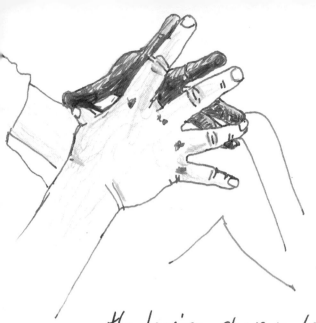

the tension shows in her fingers
during an episode of Everything's
Rosie

Helping with Homework

→ Me: "So you have to try to find the
biggest number possible by combining
the 1ˢ and 2ˢ using either + or – ..."

– "Oh look at that cloud, Mum!
 it's like a turtle with really long legs!"

A Hand dryer looks like this.

But if you are a small child, it looks more like this.

I am going to dry your hands.

ROAR
ROAR
I'M GOING TO GOBBLE you up.
ROAR!

The Contents of My 5-year-old's pocket

1 x gold-plated
ear stud. (origin unknown)

1 x plastic emerald

1 x Screw

1 x nut _and_ bolt

2 x Hawthorn leaves

1 x Conker

1 x Five Pence Piece

1 x Cashew Nut

Modern Names

"India's going to Thailand today."

conversation with my daughter
(5 years old)

- Mum? What am I allergic to?

Me - Nothing.

- That's not fair. I want to be
allergic to something.

Me - why?

- EVERYONE has one, except for me
Joni, Betsy, Anahita, oh, no, she's
deaf. I used to be deaf.

Me - A bit, but you had an
operation and you're fine now.

- I know. We need to think of
something.

Charming

- Mummy?
- Yes?
- You know when I tell you I love you?
- Yes?
- Well I only say that when I can't think of what to say

— how was school today?

— Isobel made Camilla cry, because Camilla wanted to die in the game, and Isobel said "No dying in my game". and that made Camilla cry because she just wanted to die, she didn't want to do the other things, so I said to Isobel, you must let Camilla die in the game but anyway, Camilla didn't in the end, she went to play crocodiles with the bigger girls & she got eaten.

Crêpe Outrage

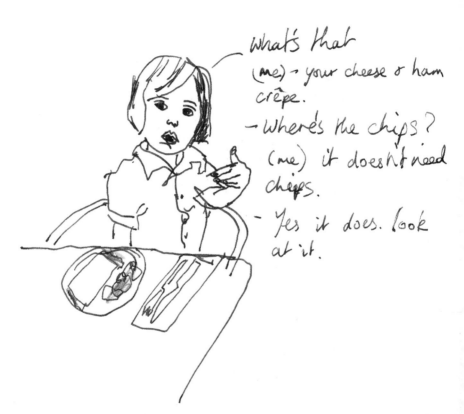

What's that
(me) → your cheese o ham
crêpe.
→ Where's the chips?
(me) it doesn't need
chips.
→ Yes it does. look
at it.

Knackered Mum
in stripy hat
Pushing
Knackered
baby in
Stripy hat

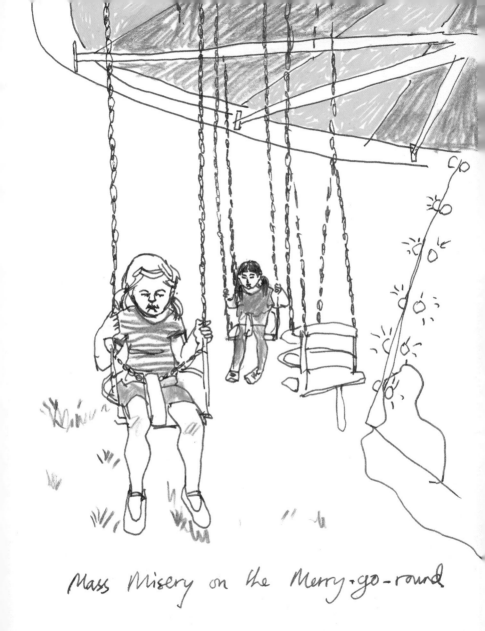

Mass Misery on the Merry-go-round

The Chocolate Advent Calendar So Far.

Dec 1st

— "No darling, you can only have one."

Dec 2nd

"No darling, — you can only have one"...

Dec 3rd

— "No darling, you can only have One"

Teddy

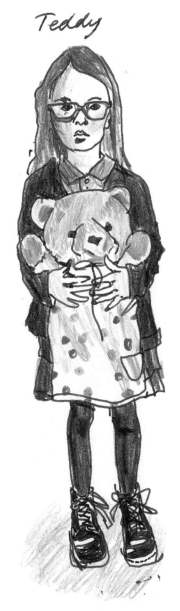

Owner: Mathilde

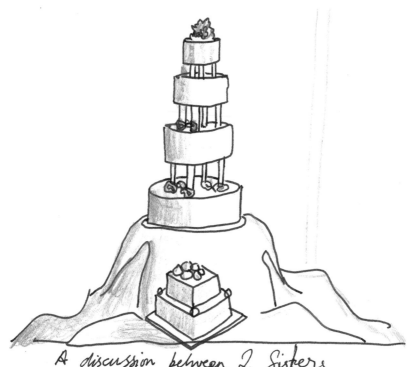

A discussion between 2 Sisters

7-year-old: Oh my god. Look at that
girl: amazing cake

3-year-old
girl: ha ha! Its disgusting!

7-year-old: Well you're going to get
married one day, and then
you won't be laughing.

Iggle Piggle

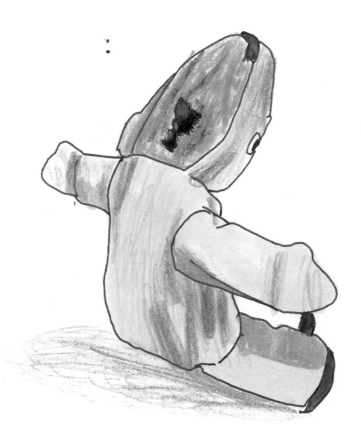

Owner: Sam

Dialogues:

- "Sweetheart, are you hungry?"
- (SILENCE)
- "Are you hungry? Kizzy... Are you hungry?
- (SILENCE)
- "Kizzy. KIZZY! for god's sake. Are you hungry?"
- "Mum, can you please stop repeating yourself?"

when asked what being a Mum is
like I said the following. (and I quote)
Mum! Mum.
Mu-um.
Mummy Mummy Mummy!
Mum-Mum-MUM-MuM
-MUM MUM
mum, mummy, Mummy,
Mum Mu-HUM
Mummymummy Mummy

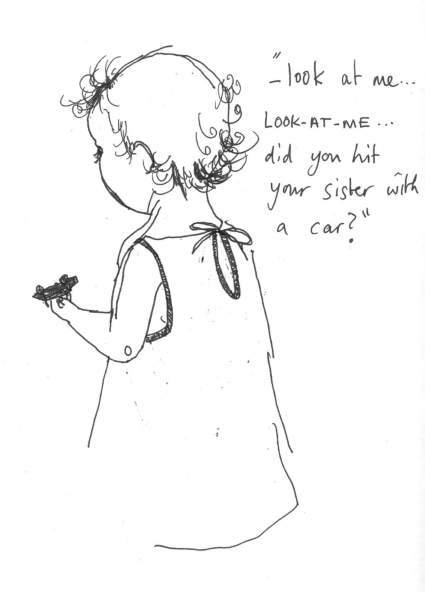

Mr Sock Monkey

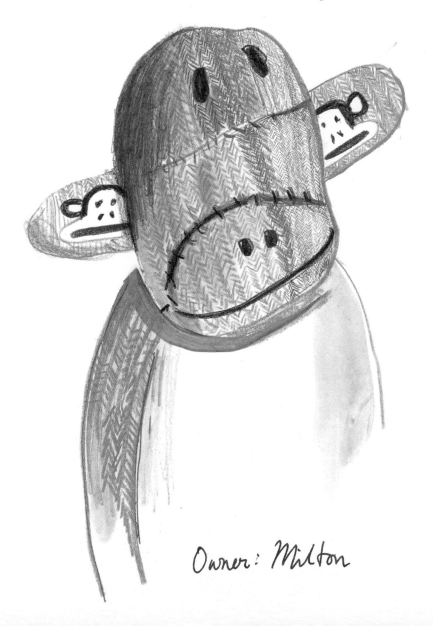

Owner: Milton

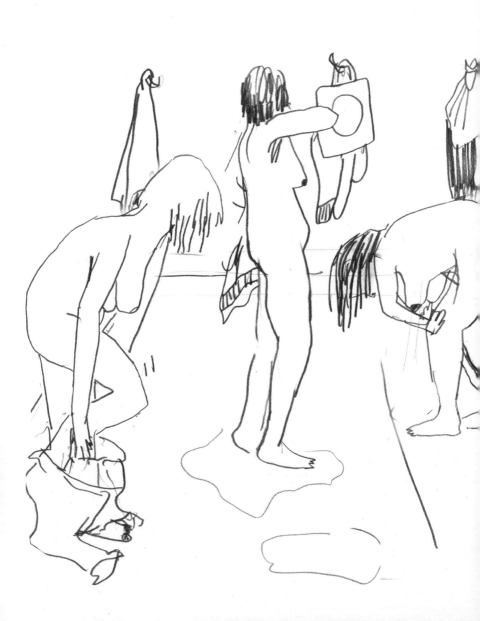

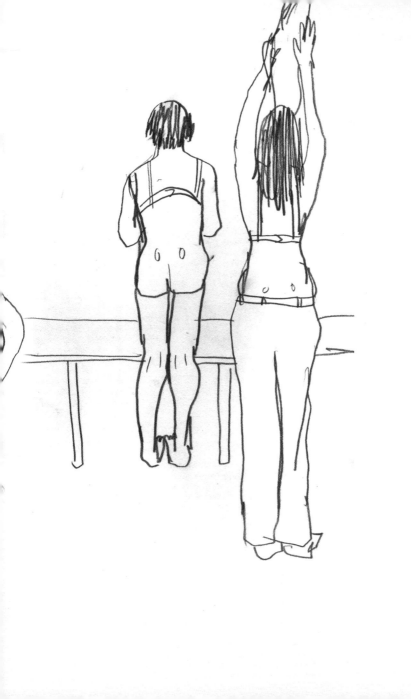

– Get your coat. We're going to Marks + Spencers.

– OK. AND MY GUN. I'LL NEED MY GUN.

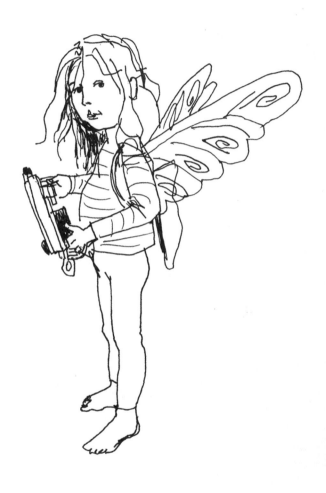

Week 6 of fairy wings & a gun
phase.

First Published in the United Kingdom in 2016 by

Pavilion
1 Gower Street
London
WC1E 6HD

ISBN 978-1-91023-283-5

A CIP catalogue record for this book is available from
the British Library.

10 9 8 7 6 5 4 3 2 1

Reproduction by Mission Productions Ltd, Hong Kong
Printed and bound by 1010 Printing International Ltd, China

This book can be ordered direct from the publisher at
www.pavilionbooks.com